LA CASA AZUL

T0262453

Sophie Faucher

LA CASA AZUL

Inspired by the writings of Frida Kahlo
Translated by Neil Bartlett

OBERON BOOKS
LONDON

WWW.OBERONBOOKS.COM

First published in this translation in 2002 by Oberon Books Ltd.
521 Caledonian Road, London N7 9RH
Tel: +44 (0) 20 7607 3637 / Fax: +44 (0) 20 7607 3629
e-mail: info@oberonbooks.com
www.oberonbooks.com

A catalogue record for this book is available from the British
Library.

PB ISBN: 9781840023480
E ISBN: 9781849439596

Cover photograph: Yanick Macdonald

Contents

A London Original

Hidden away behind a concrete facade on a busy high street, the Lyric has always been one of the most surprising theatres in London. Our work matches the building in its boldness: Kleist, Marivaux and Dumas alongside collaborations with Improbable Theatre, Frantic Assembly, and Robert Lepage; distinguished contemporary popular music alongside a truly magical annual Christmas show. In the course of a typical season, the Lyric takes pride in creating distinctly different nights out – but each one is stamped with the hallmark of a show at the Lyric: originality.

Next year, while all of this work is happening on our stages, we are also taking the building itself into an important new phase of its life. A new purpose-built rehearsal room will finally give Lyric artists the working conditions they deserve; a dedicated education space will enable our acclaimed work with children and young people to reach even further; and a dramatic new glass-fronted entrance sweeping down into a newly created Lyric Square will celebrate the intimate relationship between the theatre and its neighbourhood.

In the meantime, some of the most important things about the Lyric will not be changing: free first nights for local residents, great value tickets, bargain prices every Monday – and an audience as varied as the city we live in. The doors of this theatre, I'm proud to say, are wide open.

Neil Bartlett
Artistic Director
October 2002

Lyric Theatre Hammersmith, King St., London W6 0QL
Tel: 020 8741 0824
Fax: 020 8741 5965
Email: enquiries@lyric.co.uk

Cultural Industry

CULTURAL INDUSTRY is an independent, international production company, based in London, that produces and presents new work across a complete spectrum of the performing arts.

Established in 1987 by Michael Morris, Cultural Industry has been responsible for on-going presentation of work in the UK by **Robert Lepage, Pina Bausch, La La La Human Steps** and the production of special projects by **Brian Eno, Laurie Anderson, Jan Fabre, Heiner Goebbels** and **Robert Wilson**, amongst many others, in a range of leading venues throughout the UK. Cultural Industry's current international touring production is the highly acclaimed *Shockheaded Peter*, which has now been seen across four continents and has recently finished it's second highly successful West End run. Other plans for 2002 include **Pina Bausch Tanztheater Wuppertal**'s *Kontakthof*: the re-mounting of an early work to be performed by a group of senior citizens from Wuppertal, at the Barbican.

Michael Morris is also, with James Lingwood, Co-Director of Artangel, which commissions and produces new work by exceptional artists in unusual locations. Past commissions include Michael Landy's *Breakdown* at the C&A building on Oxford Street, Alain Platel's *Because I Sing* at the Roundhouse, Jeremy Deller's *The Battle of Orgreave* in South Yorkshire and Atom Egoyan's *Steenbeckett* at the former Museum of Mankind. This autumn Artangel celebrates a decade of projects with new works in London by Richard Wentworth, Shirin Neshat, Steve McQueen and Matthew Barney.

For Cultural Industry
Director: Michael Morris
Associate Producer: Christine Gettins
Project Co-Ordinator: Carol Atkinson

Ex Machina

EX MACHINA is a not-for-profit creative theatre company which was founded in 1994. It is an informal grouping, under the artistic direction of director Robert Lepage, of a team of creators, performing artists and technicians hailing from various artistic circles.

In addition to the production of essentially theatrical work (e.g., *The Seven Streams of the River Ota, Elsinore, the far side of the moon*) the theatre troupe has gradually been branching out over the past three years by entering new fields, such as: publishing (through interviews with Mr Lepage and the texts of certain shows); multimedia (the *Metamorphosis* Web site); music (*The Damnation of Faust, Kindertotenlieder, Jean sans nom*); cabaret (*Zulu Time*); and museology (*Métissages*). The theatrical dimension nevertheless permeates all work accomplished by the troupe.

Since 1997, Ex Machina has been in operation in a creative studio located in a renovated fire station known as 'La Caserne Dalhousie' in Québec City, where all its projects come to life. Its theatre productions are usually taken on tour and staged before live public audiences in various venues throughout North America, Europe, Asia and Oceania.

In 1996, the directors of Ex Machina founded a production company for cinema and television endeavours known as In Extremis Images Inc. Its primary mandate is the screenplay adaptations of productions initially intended for the theatre, in particular, the shows produced by Ex Machina.

Associate producer, Europe, Japan: Richard Castelli
Associate producer, United Kingdom: Michael Morris
Associate producer, North & South America, Australia, New Zealand: Menno Plukker
Producer for Ex Machina: Michel Bernatchez

Ex Machina is funded by the Canada Council for the Arts, Department of Foreign Affairs and International Trade, Quebec's Arts and Literature Council, the Ministry of Culture and Communication, the Fonds de stabilisation et de consolidation des arts et de la culture du Québec, the City of Quebec.

Introduction

Is it true that strokes of paint can come alive, that they can give life?
Frida Kahlo

From 1942 until her death in 1954, Frida Kahlo kept a journal which has since become known as her *Intimate Diary*. The pages of these small notebooks are crowded with painted juxtapositions of slogans, text and image, and they provide both a record of and key to the obsessive recurrent themes of Kahlo's work; her relationship with her own body, with her beloved Diego Rivera, with the Russian and Mexican revolutions, with her struggle to find an art adequate to express her life.

The diary, with its vivid, highly personal juxtapositions of private and public, of image and text, is a particular version of the essential surrealist artform – *collage*. It has been the main inspiration behind this theatrical meditation on Kahlo's life and work. Historical incidents are intercut or overlaid with (sometimes, quite literally) motifs from paintings; documentary texts are used alongside the most personal, lyrical entries from the diary; images flourish where words alone cannot convey the sheer strangeness and intensity of this woman's life. The collaboration between Sophie Faucher and Robert Lepage has resulted in a piece of theatre which is not just 'about' Frida Kahlo; through its particular, personal combination of performance, text and image, it invites the audience to experience not just her world, but her way of seeing the world. For Kahlo, a revolutionary politics and an extraordinary life meant forging an art that wasn't just capable of reflecting the revolutionary and the extraordinary; it had to itself *be* those things.

Besides the diary, the piece also uses letters, postcards and other documents from Kahlo and Rivera's life and times.

One other source is key. La Casa Azul – *The Blue House* – is the name of Frida Kahlo's house, in Coyoacán, a suburb near Mexico City. The house is named for the colour of its walls, which Kahlo had painted an intense, beautiful azure. She was born there in 1907, and returned frequently at times of both crisis and happiness; it finally became both her sanctuary and her only workplace. She had lived, worked and taught in Coyoacán only intermittently during her early career, but then moved there permanently in 1941 with Diego Rivera, ending years of travel necessitated by work, medical treatment and her tempestuous on-off-on relationship with her husband. Following her death there on 13 July 1954, La Casa Azul was turned into a museum of Kahlo's work, and presented, in accordance with the wishes of Diego Rivera, to the Mexican people.

The staging of *La Casa Azul* takes as its physical starting point a three-dimensional memory of Faucher and Lepage's impressions of Kahlo's home and studio, with its extraordinary blue walls, its particular atmosphere of potent calm amidst a tempest of memory, and its furniture and exhibits. In Coyoacán, Kahlo's diary, her death- (and life-) bed, her wheelchair and her easel with its last, unfinished painting are all just as she left them. Out of these impressions Lepage has created a new space, one in which the strokes of paint can, indeed, both take on and give life.

The text of *La Casa Azul* printed here is not exactly a playscript in the conventional sense. The piece is as much visual as verbal; the stage pictures and projected images which constantly interact with the actors-as-characters cannot be adequately recorded in print. In addition, this is a record of a theatrical collaboration as it stood at a particular point in its working process. Lepage's working method is to continually re-think with his collaborators, to re-work and re-investigate a piece until it finds its final, true form; he is himself a kind of *collagiste.* Moments, images, sounds, speeches and even entire scenes shift, are deleted, reinvented and transposed from one key or scale to another as the show is re-rehearsed.

The performances at the Lyric Hammersmith, which were the first time that the piece has been given in English, were the occasion of extensive re-working; what follows is the text as it stood on the first day of rehearsals in London.

Although the translation bears my name, it was made in close collaboration with Sophie and Robert, and was closely informed by our discussions about the new directions that putting the piece into a new language allowed. My thanks to them for allowing me to join them in their work, particularly now that I know something of why Kahlo and Rivera matter so much to them as fellow artists. Thanks also to Lise and Patric, whose performances as the hieratic, chameleon figure of La Pelona – one of Mexican folklore's many incarnations of Death – and as Rivera – sun to Kahlo's moon – provoked me to find the right words.

<div align="right">
Neil Bartlett

Lyric Hammersmith

October 2002
</div>

Characters

FRIDA KAHLO

DIEGO RIVERA

LA PELONA

TINA MODITTI

CHRISTINA KAHLO

LEON TROTSKY

AN OFFICE WORKER

A NURSE

A RUSSIAN NURSE

This translation of *La Casa Azul* was first performed at the Lyric Hammersmith on 11 October 2002. The cast was:

FRIDA KAHLO, Sophie Faucher

DIEGO RIVERA, Patric Saucier

LA PELONA, TINA MODITTI, CHRISTINA KAHLO, LEON TROTSKY, AN OFFICE WORKER, A NURSE, A RUSSIAN NURSE, Lise Roy

Director, Robert Lepage

Director's assistant, Lynda Beaulieu

Assistant to the director, Normand Poirier

Set designer, Carl Fillion

Lighting designer, Sonoyo Nishikawa

Costume designer, Véronique Borboën

Properties, Sylvie Courbron

Make up and hair, Angelo Barsetti

Wigs, Rachel Tremblay

Assisted by Claude Trudel

Images produced by Jacques Collin

Assisted by Lionel Arnould

Set building, Les Conceptions Visuelles Jean-Marc Cyr

Production manager, Louise Roussel

Production assistant, Marie-Pierre Gagné

Tour manager, Annie Pilon

Technical director, Patrick Durnin, Robert Lemoine

Technical consultant, Tobie Horswill

Technical director (touring), Frédéric Labelle

Stage manager, Nathalie Godbout

Lighting manager, Laurent Routhier

Sound manager, Frédéric Auger

Video manager, Francis Leclerc

Costume and property manager, Sylvie Courbron

Chief stagehand, Jean-Pierre Gallant

Produced by Ex Machina

Music

Arvo Pärt *Tabula Rasa, Fratres, Cantus in Memoriam of Benjamin Britten*
Used by arrangement with European American Music Distributors LLC, agent for Universal Edition Vienna, publisher and copyright owner
Tabula Rasa used by kind permission of Naxos of America, Inc.
Fratres Performed by I Fiamminghi / Conducted by Rudolf Werthen From Telarc CD-80387
Tomas Ponce Reyes
Lucha Morena
Tita Ruffo

Film

Excerpt *Belle of the nineties*	Universal Studio Licensing, Inc.
Excerpt *The Heat's on*	Columbia Pictures

English language production commissioned by the Lyric Hammersmith & Cultural Industry. A co-production with Cabildo Insular de Tenerife, Tenerife; Pilar de Yzaguirre-Yscarca Arts Promotions, Madrid; Théâtre d'Angoulême, Scène Nationale, Angoulême; Théâtre de Quat'Sous, Montréal; Wiener Festwochen, Wien.

Scene 1: The Colours

A tourist is visiting the Casa Azul in Coyoacán. The exhibits include Diego Rivera's stepladder and Frida Kahlo's bed, easel and wheelchair. Having checked that there is no security guard in the vicinity, she removes the rope barrier and walks into Frida's studio. The artist's 'Intimate Diary' is lying on the wheelchair. She picks it up and opens it at random.

She closes the book again and puts it on the easel. She picks up a photo of Frida which she fixes above the canvas, then opens the paintbox and chooses a paintbrush. She starts to make herself up using Frida's palette of colours.

Black; nothing is ever really black. Nothing. Black is all colours.

Magenta; the juice of a cactus-flower, dried blood from a barbary fig; the most vivid of pigments, the most ancient.

Green...; a calm, warm light. Leaves, Melancholy, Science...the whole of Germany is green.

Blue: Azul; nerves are blue. Electricity, Purity – and Tenderness. Tenderness herself is blue, sometimes. Cobalt blue – mixed with red and green, it can avert the evil eye... Azure – Aztec blue, Aztec blue for the walls of this house... Ultramarine; the depths of love.

And Yellow; yellow belongs to the sun and to joy. To the purity of love. Yellow – fever, cowardice; madness. Madness is yellow; but pain, what colour is pain? What colour is the pain of the Mexican people?

Because that was part of why she painted too; to show their dignity, their greatesss.

Green: the cactus.

White; Purity.

Red; Blood. Blood of sacrifice, shed for The Country. The blood of the Mexican people.

It took a genius like Diego Rivera to tell their story. The old world of the Indians, where the Gods walked the earth like lords, where men were tied by blood to the Sun, to the Great Waters, to the Moon, to Quetzacoatl, the Plumed Serpent. The great Aztec soul – which she sucked in at her mother's breast. And then, the story of the Conquest: Mexico groaning under the Spanish yoke. Pillage and cruelty, the barbarities of the Church, her people crucified. And at last, like a great breath of wind: the Marxist revolution, the vessel of all their hopes.

The Art of Diego Rivera and of Frida Kahlo: this is where the real revolution took place: every line, determined by the Golden Rule.

The tourist becomes FRIDA.

Scene 2: First Meeting

FRIDA and DIEGO meet.

FRIDA: Maestro Rivera, I've come to show you my paintings. If you think they're any good, say so, if not, then say that, and I'll find another job to support my parents.

She shows him three portraits of women.

DIEGO: They're good. They're really good. Especially the self-portrait, it's more...personal. I like the sensuality that's coming through.

FRIDA: It's not me, it's my sister Christina.

DIEGO: They're good; none of the usual beginners' tricks.

FRIDA: Please I don't need compliments. I need proper professional advice from somebody who knows what they're talking about. That's why I've come to see you. You see maestro painting isn't a hobby for me, I'm serious. And also I have got to earn a living.

DIEGO: As I was saying...; you're a painter. Don't you trust my judgement?

FRIDA: I don't know... People told me not to believe a word you say.

DIEGO: So why've you come to pester me?

FRIDA: They told me if a girl wants your opinion, and she's not totally disgusting-looking, you give her lots of compliments.

DIEGO: That's not all I give her...and did they also tell you I like little girls' brains on toast for breakfast?

FRIDA: (*A bit worried by that.*) Listen, I just want to know, should I carry on painting? Or would I be better off doing something else?

DIEGO: You have talent. So; yes, even when it gets hard, carry on painting.

FRIDA: There's other paintings I've done I'd really like to show you – could you come to my parents' house, next Sunday? I live a bit out of town, at Coyoacán, ciento veinte seis Calle Londres. I'm called Frida, Frida Kahlo.

Scene 3: The Bath I

DIEGO gives FRIDA her bath. She tells him the story of her accident.

DIEGO: Ah! What a back…a real work of art.

FRIDA: But Diego, it's covered in scars.

DIEGO: (*Holding her.*) Every one a beauty!

FRIDA: You're the only one who ever makes me feel lovely. You find me in pieces, and you make me whole. The two great accidents in my life – meeting you, and the tram…my god, it's a miracle I wasn't killed. I was standing in the bus…

DIEGO: The one that runs past the San Juan market –

FRIDA: A painter in overalls, carrying a bag of gold-paint powder, had just got up and offered me his seat. It was a funny sort of crash; a collision between a bus and a tram…not violent, but muffled, slow…and it smashed…smashed everything. Me worse than the others. The shock threw us out through the front of the bus, and the handrail on the tram went right through me. A metal shaft entered me, through my left thigh, and came out through my vagina. A bull, skewered by a sword; a matador, gored, spiked on a horn.

There was an explosion of gold powder and I could hear some children calling out 'Mira la Baïlarina, mira la Baïlarina.' Blood and gold, spilt, scattered.

That was the day I became a woman: fucked by a tramline.

It's a terrible thing to learn about life in a flash, to be shown the world by lightning. I've got used to living in pain now, to my life being clear as ice; but it was like suddenly knowing everything, everything, in seconds. My friends, my schoolfriends, they turned into women gradually; but I grew up right then and there, and since that day the world I live in is flat, open, and quite transparent. I know that this is all there is, because if there was something else, then I'd see it.

Scene 4: Total eclipse of the heart

LA PELONA marries DIEGO and FRIDA; the Heavens blaze with darkness.

LA PELONA: You, Diego, you shall be called Auxochrome; he who takes colour.

And you, Frida, you shall be named Chromophore; she who gives colour.

Day shall follow day; you shall render, and you shall receive; receive, and render. Neither shall exist without the other. Sometimes affection and love will bring you close; sometimes, hate will tear you apart. But in death you shall be united, and will shine as one, sun and moon conjoined. Know this; your sign in the heavens is fixed. One everlasting eclipse.

Scene 5: Pinata I

DIEGO and FRIDA are embarrassed at first, but then they start to slow-dance – and DIEGO starts to eye up another woman. He spins FRIDA around and shoots off his pistol. Her walking-stick becomes the cane used to thrash and smash la Pinita. FRIDA collects the coins and sweeties, then DIEGO leads her towards the surprise delights of her wedding night.

Scene 6: The wedding night

TINA MODOTTI, fag in mouth, awaits our turtledoves in their honeymoon bed. She's been hired to introduce FRIDA to the pleasures of the threesome.

Scene 7: Film: 'American Beauty'

Miss Mae West is America Incarnate – and All Woman.

Scene 8: Mr and Mrs Rivera in the US of A

DIEGO: Propaganda! Propaganda! All Art is Propaganda!!! Religious painting – political painting – it's all Propaganda, all of it!! The question is; propaganda for what?

FRIDA: Here in San Francisco I feel freer and lighter than in any place I've ever been. For the first time in my life, the world is my oyster. Diego is a hit, I am Senora Rivera, and they *love* me.

DIEGO: Art is an essential part of human existence; therefore it cannot belong to just a privileged few.

Art is the language of all humanity, and so must belong to all members of society. In the end, an artist is no more and no less than a human being. A profoundly human human being. That's all.

FRIDA: Ah, los 'Gringos' – they all look the same! – pale and pasty with their faces like badly cooked bread. Impossible to paint – even Diego says so. Crazies, kids, stuffed to bursting like the accounts in the big fat Capitalist banks...

DIEGO: If an artist is incapable of sharing in the sufferings of all humanity – if an artist cannot so love his fellow man that he forgets himself, that he will even lay down his own life, even abandon his work –

– if he is not prepared to lay down that magic paintbrush and take up arms against the oppressors of The People –

– well then he's not a great artist.

FRIDA: The Workers in the factories, they're more like it. The ones we met at 'La Rouge' in Detroit, they're my kind of people. The world they live in is sinister – but magnificent – a universe of steel, fire, cement. A devil's *symphony!* – that has Diego completely spellbound. He paints like he's possessed. And I –

I am carrying our child.

DIEGO: A great artist is a man who truly loves his neighbour, one who lives and works only in order to contribute everything he can – anything he can – whatever, however, whenever – to harmonious relations between Man and Man's world, between Man and his fellow Men.

FRIDA: I can feel you, feel you inside me. Feel you
growing, taking root in the pit of my stomach as if
my guts were your native soil. Safe, and warm.

Scene 9: The Bath II

FRIDA has a bath. She has a miscarriage.

Scene 10: A letter to Christina

*With Los Laureles as their soundtrack, two puppets put
on a show.*

New York, 23 November 1933.

My little sister Christina – Papa has written to me
that your husband's left you. The monster's gone,
vanished. And now you're crying, you whose eyes
were made for laughter. Dry your tears, my darling.
We're here, Diego and I. The doors of our house are
wide open to welcome you. This will be your new
home – a new home for your lovely Isolda, and for
that long-faced little Tonito who I'm already looking
forward to getting to know better. Come and live
with us. The cloud you're under will lift here; that's
how strong our love is. Write back quickly, and just
let me know if you need any money.

Your big sister, who loves you, with all her heart,
Frida.

Scene 11: Flowing robes

FRIDA: (*Smoking a big fat joint.*) Come on, Christina,
it's Independence Day!

(*Sings.*) La cucuracha! La cucuracha! Ya no puede caminar. Porque no tiene, porque no tiene; marijuana que fumar!

Don't slump – hold your head up, like the cactus of Mexico – there's plenty more fish in the sea… Come on! Viva La Vida, Viva La Revolucion! – Viva la fiesta!

CHRISTINA: I don't feel like it…anyway I haven't got anything to wear.

FRIDA: Relax, I've got everything we need…

Looking through her dresses.

I'm going to turn you…into a Tehuanista!!… Diego's been dreaming about those women all his life.

CHRISTINA: Bunch of flea-bitten peasants.

FRIDA: They're goddesses! Living icons – covered in jewels, beribboned, shirts in bright blue and orange, skirts with flounces embroidered every colour under the sun, skirts like Catherine-wheels! – their voices strong as music, their eyes bright with pride.

CHRISTINA: They're gypsies.

FRIDA: They're Amazons! Hot-blooded; violent; free. As free as our country. You're going to be on fire tonight, flaming – that's it, Fire-woman, burning like the burning coals of Tehantepec –

CHRISTINA: (*Swathed in FRIDA's draperies, inspects herself.*) It's not really me…

FRIDA: It's what you need. Live a little.

CHRISTINA: Yes but you can get away with it; you're a surrealist.

FRIDA: Surrealism my arse. Surrealism is when you open the wardrobe, and out comes a lion, when all you wanted was clean underpants.

CHRISTINA: Underpants.

FRIDA: Underpants.

The sisters collapse in laughter as they realise what a ridiculous statement this is.

Oh god, the jewellery! Where is it – they've stolen it – my riches, my fortune (*FRIDA finds the jewellery case and puts it in her sister's lap.*) …take anything you want…what about some earrings…amber for good luck, gold for *love*…no not those, they were a present from Picasso!…try these…

CHRISTINA yelps when FRIDA puts the earrings on her.

Have you seen the rings? All my rings…take some, personally I like one on every finger… Every ring tells a story; it's good they're all going to the party.

CHRISTINA picks what she wants and shows her hands to her sister.

Fabulosa!! You shall go to the ball!

She takes her sister's hand and plays at fortune-telling.

I see…I see…I see nothing…but I foretell that within three hours, or days, or possibly months, you shall lie in the arms of your royal beloved.

Reaching out towards each other, hand in hand, as FRIDA launches into a poetic rhapsody.

Our hands, bejewelled…

Every finger, illuminated…

Poem:

'The lines of your body run across my palms;
one moment I'm under your skin;
the next minute I'm back in mine.
My blood runs like a miracle
through the veins of my beating heart,
and it runs…to you.'

FRIDA embraces CHRISTINA tenderly; they are ready. DIEGO works on his fresco 'Dreams of a summer afternoon; The Alameda'. CHRISTINA appears on the canvas. A game of seduction ensues. CHRISTINA leaves, and DIEGO finds himself staring first at FRIDA's face, then at LA PELONA's.

Scene 12: Betrayals

Seated at her easel, FRIDA paints Stalin's portrait.

FRIDA: Stalin, 'Little Father of the People'
It is in you that I place all my hope.
You are the one true light.
You alone have the strength to govern us in Justice and in Peace.
So tell me; why did you have Trotsky killed?

All my life, I have lived to serve the Revolution.

When he was on the run, because your rift over the centralisation of power had driven him into

exile, I sheltered him under my roof; I turned my blue house into a block-house to protect him – him, creator of the Red Army, comrade in arms, Lenin's comrade, yours.
Diego, and I, we even put pressure on President Cardenas to let our Mexico grant him asylum. I loved him. Through him, I came to love Diego and his revolutionary thinking. I came to love The People. Trotsky was History.

TROTSKY recites Pushkin to FRIDA in Russian; Eugene Onegin's letter to Tatiana; DIEGO translates:

DIEGO: I know my days are numbered…
But as long as I live…
I need to know when I get up in the morning that I'm going to see you before bed-time.
I cannot hold out against you any longer…
Everything's settled…
You're my fate…
Do with me what you will.

FRIDA: Gracias.

TROTSKY: Pouchkine.

DIEGO: Tequila!

TROTSKY gives the book of Pushkin poems to FRIDA; DIEGO offers a sugar skull inscribed 'Trotsky' to his idol; FRIDA gives him a self-portrait for his birthday.

DIEGO paints a fresco…he feels like dipping his wick…he seduces FRIDA and puts her dress on CHRISTINA's body.

A domestic;

FRIDA: You just can't help yourself can you – you piece of *shit*. My sister – my own sister!

DIEGO: Oh not you as well Frida… No Jealousy! – not between us, please –

FRIDA: Oh this is much worse than jealous –

DIEGO: You can ask me anything you want, you know that, just not…to be faithful. All these women, they're beautiful – why say no?

FRIDA: So you get off with schoolgirls, with your students, with journalists, with rich foreign bitches who get wet every time they look at one of your pictures, fine; fine…you've got so many notches on your brush I'm surprised it can still fucking paint.

DIEGO: Calm down, companera; they don't count; you are now and you always will be the only one. I can't help it…and I don't want to…and you know me giving one to some bitch means about as much as me taking a piss, so why should you be the only woman I know to take it so seriously?

FRIDA: Pig! I am not Woman; there are Women, and there's Me. And I've put up with this for years. Don't compare me to one of your whores! I'm from a different world.

DIEGO: We made an agreement, if you remember –

FRIDA: It didn't include my family! I feel sick. Christina, my little sister. Oh! You bastard, filthy, filthy bastard! I feel unclean. I feel ashamed to have the same name as you.

DIEGO: And I feel like fucking something else besides a cripple who hasn't come in years.

FRIDA finds herself on her own again; she gives way. TROTSKY comes back and consoles her. DIEGO bursts in. He threatens FRIDA with a gun. She runs. He points the gun at TROTSKY, who doesn't flinch. DIEGO leaves. TROTSKY takes the sugar skull from where he placed it on FRIDA's easel. 'He' removes his glasses, his moustache, his goatee and his wig and puts them on the skull. 'He' is revealed as LA PELONA; she shows the audience the image of TROTSKY as a deathshead, and stares disquietingly straight at them.

Scene 13: Shorn locks

FRIDA: If I just…had someone to touch me.

Touch me like the wind running across a field; everything would be different. I wouldn't be hurting like this. I wouldn't be driven this far.

FRIDA puts on a suit of DIEGO's, and hacks off all her hair. Night has fallen.

This dark night of mine beats like a wounded heart. It has no moon…

This dark night stares wide-eyed at the window, stares blankly at that faint grey light. This night is long, so long, so long and it leads me I know not where. You are gone, and this night hurls me down into that great pit. I reach for you, reach out for that great fat body next to mine, the sound of your breathing, your smell, and the night replies: the bed's empty; I've got nothing for you but cold; you're alone. This dark night of mine longs to call out your name, but she's lost her voice. She longs

to call out to you and then find you and warm herself against your body for just a moment and oh forget these hours that are the death of me, death of me. This night burns for you.

It wears me out.

If this night had wings, it would fly straight to you; gather you up as you lay sleeping and bring you safely home – and you'd wrap your arms around me without even waking.

This night has no words of wisdom to offer.

This night thinks only of you; dreams of you with eyes wide open; laments, and paces and paces its room. It is long, so long, so long. The night wants me to get some clothes on, get outside and look for him, but she knows that would be crazy, I mustn't do that, mustn't, can't. She wonders if there's anything left I *can* do. I could always join her, give myself to her – people do, she knows that, but she doesn't like the idea of flesh surrendering itself just out of despair. Flesh was meant for flesh, never for the abyss.

This dark night of mine loves you in the very depths of her heart, and in that darkness my love echoes hers.

This night hungers for every imagined morsel of sound; its eyes never leave me – they glide like moonlight, slide into every crevice; if you were only here, how she would caress you, so gently; so gently. This night aches for you.

This body waits for you.

This night wants to watch you as you come, you
first, then me, both of us shaking with pleasure.
This night wants to watch us gazing into each
other's eyes, she wants every look to be a lover's.
She wants to feel you jump between her hands…
oh she would make herself so sweet, so sweet…
This dark night of mine bites her lip when she
thinks of you.

This night is long, it's long, so long; she will die
with losing you, and take me with her.

Her search has no end.
She howls and rends her veil;
No longer can she hold her tongue,
But nowhere can she find you.

I miss you more and more.

Miss the sound of you.

The colour…

It is dawn; she becomes aware of the first light.

…it must be nearly morning…

Scene 14: 'Lecheria Pinzon'

FRIDA: I knew you'd turn up tonight. I've tried
so hard to forget about you. Forget my parasite,
chewing away like a maggot in an apple. But I
must be like a cat; nine lives.

Allegria, la Muerte!! Tonight's the night; my
Coronation!!

FRIDA takes a swig of her medication.

Oh I know, I know, I'll kill myself – and right on cue, here's Miss Death, spying on me…prowling round…loitering – with intent. But then you've been there right from the start, we're inseparable; I know that; I know it's you who'll be having the last word. It's been years you've been setting traps for me, years I've been dodging you.

LA PELONA: Do you remember the little girl at the dairy?

FRIDA: What are you talking about?

LA PELONA: When you were small – you must have been about six – you used to breathe on one of the panes of glass in your bedroom window, and then, with your finger, you used to draw a door…

FRIDA: …and through that door I ran happily away into my dreams: I sailed across the wide open spaces that yawned beneath me – there was a dairy, which had a shopfront saying 'Pinzon'; I passed through the O of 'Pinzon', and descended into the bowels of the earth…where my imaginary friend was waiting for me, always. I can't remember what she looked like, what colour she was; but I remember she was always laughing… and dancing –

LA PELONA and FRIDA dance together.

How long did I stay down there with her?

LA PELONA: Can't remember now – seconds, or a thousand years. And you never asked yourself who that little girl there by your side was?

FRIDA: Was it you, already?

LA PELONA: Me: Death was the echo of your
heartbeat even then; getting louder, growing stronger.

Scene 15: Rockefeller fresco destroyed

New York, May 4, 1933.

Mr Rivera, the description which you gave us, last
November, of your proposed mural for the central
hall of the new Rockefeller Centre, together with
the sketches which you presented at that time, lead
us to believe that your work would be of a purely
imaginative nature.

There appears to have been no indication, either
in the description or in the sketches, of your
intention of including a portrait of Lenin or any
other such controversial subject matter. Under the
circumstances, we can only conclude that you have
exploited this situation in order to realise certain
elements which were not agreed between us at the
time that your contract was drawn up. We must
therefore, with great regret, terminate your work
on the aforesaid mural. Please find enclosed a
cheque for fourteen thousand dollars. Best wishes,
Nelson Rockefeller.

Scene 16: Pinata II

FRIDA in a corset, seen through the easel.

FRIDA: Doctors are pigs… Broken, they've broken me!

Sure, go ahead, Gentlemen, cut me; cut me – be
my guests. Reorganise the whole thing; smash it
up, tear it apart, wreck it.

And then to put it all back together, which corset this time? – no, please, you choose. The plaster one – or the leather perhaps, or how about steel? And you may as well whip that leg off – and that right foot, that'll have to go – do I *need* feet? What for? What do I need feet for when I've got wings to fly with –

She starts praying, sotto voce, terrified.

Angel di mi garda
Dulca compania
No me desampares
De noche, ni de dia ni en la hora de mi muerte
Amen

Angelito, cuida a Magdalena, Carmen, Frida
Kahlo de Rivera

Scene 17: Russian Roulette

DIEGO, drunk and in despair, plays Russian Roulette.

Scene 18: Reconciliation

FRIDA, in hospital, is visited by DIEGO. He brings her puppets as a present. He makes her laugh, and persuades her to take some food, and takes her to watch;

Scene 19: Film: 'Puppet Trumpeter'

Scene 20: The Contract

DIEGO and FRIDA are seated in an office in San Francisco, where they have come to sort out the details of their marriage contract. FRIDA is smoking. An All-American B-movie secretary brings in an ash-tray.

OFFICE WORKER: So, let's have a look at this request for a marriage authorisation…

Second time around…well, *that* doesn't happen every day. You must be thrilled.

Silence.

Okay…so; you are registered under the name of (*Dreadful Spanish accent.*) Magdalena Carmen Frida Kahlo Calderon, correct?

FRIDA: Si.

OFFICE-WORKER: And your profession is –

FRIDA: Painter.

OFFICE WORKER: And you Sir are registered under the name of Diego Maria de la Rivera.

DIEGO: Diego Maria De La Concepcion Juan Nepomuceno Estanislao de la Rivera y Barriento Acosta y Rodriguez.

OFFICE WORKER: Okay. Profession?

DIEGO: Painter.

OFFICE WORKER: Of course and I heard you are one fabulous painter too!

FRIDA: No he is not *faah*bulous, he is *fuck*bulous.

OFFICE WORKER: And who will be the witnesses?

DIEGO: Arthur and Alice Niendorff.

OFFICE WORKER: Can you spell that for me?

DIEGO: N I E N D O R F.

FRIDA: F. Two F.

OFFICE WORKER: Okay. Now, Miss Kahlo has added some terms and conditions to this contract, which I haven't had time to go through yet, so let's just have a look here...

'Miss Kahlo will meet all her financial needs through the revenues proceeding from her own work...'

'Mr Rivera will be expected to pay half of all domestic expenses, no more, and it is understood that Miss Kahlo will reside at her house in Coyacán, and Mr Rivera...at his house in San Angel...'

'There will be no more sex...ual relations between the two parties...'

She laughs nervously; they look at her without batting an eyelid; it's her who's embarrassed.

Well okay...sure...

'...Municipal Judge Mr George Schoenfeld will then employ the usual protocol, ending with the words 'both spouses hereby vow to be faithful till death do them part.' And then of course you will have to sign –

DIEGO: Eugh... No...this word, 'faithful', impossible.

OFFICE WORKER: Excuse me?

DIEGO: 'Faithful' is impossible for me.

OFFICE WORKER: What do you mean?

DIEGO: I have...a...I have a –

FRIDA: Sickness.

OFFICE WORKER: What kind of sickness?

DIEGO: I love women too much…I have paper with me…from my doctor…

OFFICE WORKER: (*She takes the paper and attempts to read it.*) I'm sorry, my Spanish is not so great. You know what? I'll refer this to one of my colleagues and I'm sure we can work out a contract that will be satisfactory to both parties.

So; you are summoned to appear at the Municipal Court, eleven am, December 8, 1940.

DIEGO: 8 December, it's my birthday.

OFFICE WORKER: Well isn't that great.

DIEGO: I am fifty-four.

OFFICE WORKER: Happy Birthday!

DIEGO: You excuse us, I must now go back to my work.

OFFICE WORKER: And you, er, Mrs….er…are you also working at the World Fair?

FRIDA: No, I came to San Francisco to visit my mistress.

They leave her in a state of shock…

Scene 21: Cartas; the doctor's letter

December 8, 1952.

S. Rivera, the samples taken from the genitalia during your most recent examination confirm, as we had suspected that they would, the presence of a malignant tumour. Since you have indicated to my colleague that you categorically refuse to countenance surgical removal of the member,

alternatives must now be considered. New techniques are currently being developed in the USSR. My colleague Dr Funkin in Moscow is apparently offering a quite revolutionary treatment. He and his team of surgeons will be happy to accept you as a patient on my recommendation.

Best wishes

Dr Carlos Fernandez
Surgeon in Chief
Urology Department,
The English Hospital,
Mexico City.

Scene 22: Shooting blanks

DIEGO Rivera, in hospital gown, is sitting on an examination couch (the easel, transformed). A female Russian doctor enters. She has all the charm of a Barbie Dominatrix. She lays out her instruments and then palpates the patient's testicles. He finds it very painful; she indicates he should get his feet up on the easel – the image of a gynaecological examination. His legs are spread. She attempts to examine him for the second time. Despite him being in pain, she takes some surgical forceps and uses them on him quite expertly. She pulls out an un-cocked pistol. She strips it down, cleans it out and removes a bullet stuck in the barrel. She cocks it, and checks whether it's firing properly. She puts DIEGO's weapon back in its proper place. He's almost too weak to move, but when he sees the doctor bend over to remove her surgical gloves, he recovers the will to live and puts his hand on her backside. Surprised, she straightens a little and DIEGO seizes his chance. Blackout.

Scene 23: April 1953.
An invitation to a private view

In the spirit of true friendship,
From the bottom of my heart,
It gives me the greatest of pleasure
To invite you to come see my art.

At eight in the eve'ning exactly,
– please *do* make sure that you're not late –
At the Gallery Lola Alvarez Bravo
I shall put on my best frock, and wait.

It's at 12, Calle des Amberes,
And the front door's quite easy to find;
I'm sure that you'll manage to spot it, my friends,
Unless, of course, you are blind.

All I want you to bring to my pictures
Is an honest, unpredjudiced eye –
You've read books – even written them, some of

you –
You're all experts, Comrades; that's why.

My pictures are all framed and ready –
Each one of them all done by hand –
And eager, on their walls, to meet you:
When you see them there, you'll understand…

And that is the end of this message;
It comes with good wishes, I swear – a
Grateful and humble 'goodbye' now from me,
Miss Frida Kahlo de Rivera.

Scene 24: Making up

FRIDA: Open the window! Oh, wider!! I can't breathe in here.

Listen to my turtle-doves. My blue house is singing to itself.

LA PELONA: I can't stand all that cooing. Gives me a migraine.

FRIDA: God the stench in here! – I stink like a dead bitch. It's gangrene, isn't it nurse? Yo soy la desintegration – Senora Kahlo's 'body of work' is rotting away... Laugh! come on, laugh – don't you think it's funny?

LA PELONA: So, you want to go; you really want to go to this show tonight...you can hardly move! Never mind a walking-stick, you need crutches just to get one foot in front of the other –

– and every step you take's a razor in your guts. Give in, Frida. Admit defeat. You're worn out, you can see you are. Come on...be reasonable for once in your life.

FRIDA: Reasonable! You have no idea...fuck you, Miss Death, fuck you. I am forty-three years old –

LA PELONA: Forty-six.

FRIDA: – and tonight, for the very first time, I am being honoured in my own country: a retrospective, dedicated to *my* work. The first one in twenty years, understand? I have saved every dreg of energy I've got left for tonight. Humour me; I need to believe I'm still alive.

LA PELONA: Your energy's a fake, Frida. It's a fraud. It tastes of all that stuff you swallow.

And the gossip on how sick you are's already stinking up the whole city. Lie down.

FRIDA: Me, lie down...the whole of Mexico will be there tonight. They'll all be there, all of them: painters, sculptors, the galleries, the politicians. All of them; seeing and being seen... And will The People be there? I mean real people, the people of this country. They've got to come. Maybe not tonight they won't be there – they'd be scared, quite right – but after tonight's finished – oh!, yes, they will come, they've got to – they've got to understand, got to *see* how much I love them. We'll have some drinks, laugh, sing, dance...what time is the ambulance coming to get me?

LA PELONA: An ambulance! For a big do like this! The very idea...you know people'll say you're running out of ideas to get yourself noticed. The dressing up, the jewellery –

FRIDA: I said, what time?

LA PELONA: Seven o'clock. But they're coming beforehand to get your bed. Tch – receiving her first-night guests stretched out on a four-poster!

FRIDA: You sound like some tight-arsed little housewife – you remind me of my mother.

This bed is my life. It's my cell, my Golgotha, my hiding place; it's where I *work*.

I *shall* make my entrance in an ambulance,
I shall receive people lying in state in a four-poster

and decked out like an idol, because such is my pleasure.

Tonight is fiesta – Fiesta Kahlo!! You should be glad, it's the last one…

God I'm pale. Diego will think they've had me dug up.

Older is wiser, they say – I should be so lucky. That must be what they call the 'philosophical' approach. Age shrivels you until you're a prune.

Colour, I need more colour, where's the red, I need some red. (*Lipstick.*) No, not that one, the other one, the one that suits me…makes my lips shine…and the eyes…god, look at the bags…

LA PELONA: 'A terrible beauty is born…'

FRIDA: Am I really that close to the end?

LA PELONA: A little make-up, covers anything.

FRIDA: Make-up covers nothing. Your face is a map; it shows everywhere you've ever been.

I've watched mine, in the mirror, every single day. It's been my constant companion, like it or not. And now, look at it; a mask…

A shudder runs through her.

Right, flowers and ribbons-flowers and ribbons in my hair!

A telephone rings. No-one gets it.

LA PELONA: Well aren't you going to get it? It might be the gallery.

FRIDA: I'm in no fit state.

LA PELONA: Make your entrance on a stretcher…
everyone knows you're not in the best of shape –

FRIDA: I have never asked for anyone's pity.

LA PELONA: They'd all show up for that;
'Condemned Woman Makes Final Public
Appearance'. And of course if you could actually
die, right before their very eyes, that would be the
finishing touch.

FRIDA: I'm not going.

LA PELONA: What?

FRIDA: I'm not going to the gallery tonight.

LA PELONA: Ah! Now there's a turn up.

FRIDA: I've always loved it when the ending's a
surprise.

LA PELONA: But everything's all organised. The
ambulance'll be here any minute –

FRIDA: By all means let them send a limo – but the
VIP tonight is you. You, you who are never welcome
anywhere, here's your invitation. Be my guest.

LA PELONA: What's up with you? They're all
waiting. Esta loca?

FRIDA: Eviva la Loca!! It's taken me my entire life
to earn myself a few bouquets, and now tonight it's
you who gets to receive them. Go! – you're on!!
Give the stiffs a good show for me. And me…I'll
just wait a little longer.

I've spent my whole life standing in the shadow of
a genius. Fine, that was the way things had to be;

that was my proper place. So tell me, why, after all these years, are they so interested in my work?

I took my tears and I turned them into paintings. That's it!!… Tonight, everyone will finally get to see that there's actually nothing to see! Little pictures, not great big frescoes, little pictures – and all of one thing: me.

Once all the dressing up preparations are complete;

LA PELONA: Even at the very last moment, it must be you who summons me.

Well, you never did do anything except what you wanted.

LA PELONA is lured through the mirror by the ring that FRIDA offers her.

So, is this goodbye?

FRIDA: Anyway, you said it, they're really much more interested in the sight of me dying than in seeing my paintings.

FRIDA wraps her shawl around LA PELONA's shoulders; she goes.

FRIDA hears the sound of the ambulance siren.

Fame sounds her trumpets as the Princess enters the realm of legend!! Firmes, Mexico!! This, is Frida!!

Her laughter is full of sadness.

Death is nothing. Nothing. One minute she's there, the next – she's gone. I've spent my whole life dying.

I'm going to ask Diego to have my ashes put in an antique urn and buried in the garden; and his ashes will be mixed with mine, and we'll be like two suns, blazing as one, together, for ever.

FRIDA, alone, gets her breath at last.

Old Mictlantecuhtli, Dios, don't make me wait. In one final blaze of light, take me…

And you, my Diego…you know…my eyes will always spell out your name.

'Frida' replaces the rope barrier through which she initially trespassed. The dressing-table tips to reveal a self-portrait of FRIDA; as it does so 'Frida' pulls on the tourist's coat and slips off 'Frida's' wig, and stands with her back turned, looking at the portrait of the artist in the Casa Azul.

Fin.

Printed in the USA
CPSIA information can be obtained
at www.ICGtesting.com
LVHW021003171024
794056LV00004B/1315